A Kid's Guide to Drawing the Countries of the World™

How to Draw
India's
Sights and Symbols

Melody S. Mis

The Rosen Publishing Group's
PowerKids Press™
New York

To Vinay Pande, for his help and guidance

Published in 2005 by The Rosen Publishing Group, Inc.
29 East 21st Street, New York, NY 10010

First Edition

Editors: Jannell Khu, Jennifer Way, Natashya Wilson
Book Design: Kim Sonsky
Layout Design: Mike Donnellan

Illustration Credits: Cover and inside by Holly Cefrey.
Photo Credits: Cover, p. 1 (hand) Arlan Dean; Cover (Ganesha), p. 24 © Macduff Everton/Corbis; p. 5 © Ric Ergenbright/Corbis; pp. 9, 36 © Jeremy Horner/Corbis; p. 10 © Brian A. Vikander/Corbis; pp. 12, 13 courtesy of Indian Art Circle.com; p. 16 (flag) © Eyewire; p. 20 © Tiziana and Gianni Baldizzone/Corbis; p. 22 © Tom Brakefield/SuperStock; p. 26 © V. Muthuraman/SuperStock, Inc.; p. 28 © Omni Photo Communications Inc./Index Stock Imagery; p. 30 © Garry Adams/Index Stock Imagery, Inc.; p. 32 © Steve Vidler/SuperStock; p. 34 © Michael Freeman/Corbis; pp. 36, 38 © Jeremy Horner/Corbis; p. 40 © Brian A. Vikander/Corbis; p. 42 © Charles E. Rotkin/Corbis.

Library of Congress Cataloging-in-Publication Data

Mis, Melody S.
How to draw India's sights and symbols / Melody S. Mis.— 1st ed.
 p. cm. — (A kid's guide to drawing the countries of the world)
Summary: Presents step-by-step directions for drawing the flag and national emblem of India, as well as a bengal tiger, the Taj Mahal, Buddha and other sights and symbols of Italy. Includes background information on the subject of each drawing. Includes bibliographical references and index.
ISBN 1-4042-2732-6 (Library Binding)
1. Drawing—Technique—Juvenile literature. 2. India—In art—Juvenile literature. [1. India—In art. 2. Drawing—Technique.] I. Title. II. Series.
NC655.M575 2005
743'.89954—dc22

 2003018244

Manufactured in the United States of America

CONTENTS

Let's Draw India

Civilization in India began more than 5,000 years ago in the Indus River valley. Around 1500 B.C., people called the Aryans settled in the valley. Their name means "noble ones" in their language, Sanskrit. The Aryans built cities and farmed. They practiced the Hindu religion. People who practice Hinduism believe in one God, Brahma. They also worship many other gods, which they believe to be Brahma in different forms. Hinduism is based on a caste system, which places people in different levels of society. The highest caste is the Brahmans, or priests. The Kshatriyas, or warriors, are second. The third caste, the Vaishyas, includes merchants and farmers. The lowest caste, the Sudras, includes servants and laborers.

Some Indians were unhappy with the rigidity of the caste system. Around this time, Buddhism developed in northeastern India. Indian prince Siddhārtha Gautama founded Buddhism in the sixth century B.C. The Buddhist Aśoka was India's first great emperor. He was part of the Maurya dynasty,

The first-known civilization in India grew around the Indus River, shown here flowing through the northern region of Ladakh. India was named for the Indus River. The river is home to the Indus river dolphin, a type of small dolphin that lives only in this river.

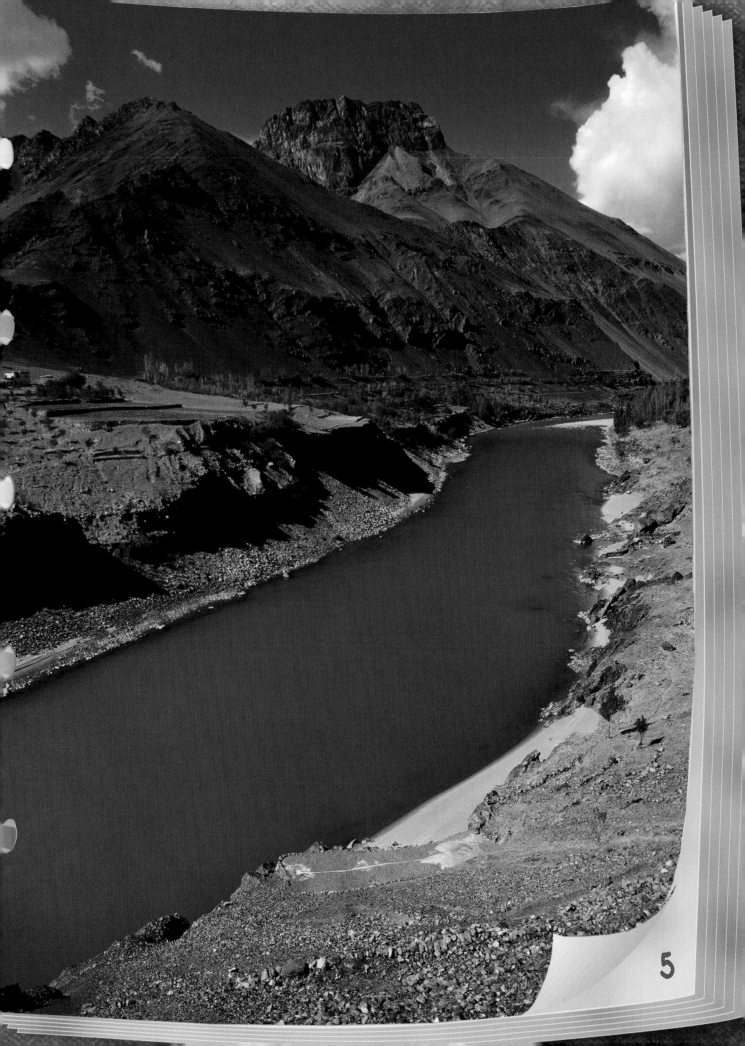

which ruled from 321 B.C. to 104 B.C. Aśoka practiced peace and nonviolence.

Between 5 B.C. and A.D. 1200, northern and southern India were each run by a series of kingdoms and dynasties. In both areas, rulers increased trade and promoted the arts. By the thirteenth century, India was divided into smaller kingdoms. Muslim tribes from the North invaded India. Muslims are people who practice the Islamic religion. Muslim leader Babur brought the kingdoms together and founded the Mughal Empire, which lasted from 1526 to 1857. The Mughals created an army and developed a tax system. They also allowed Britain's East India Company to create trading posts in India. Eventually the East India Company controlled most of India. In 1857, Indian soldiers rebelled against the British company's rule. Britain conquered the soldiers and made India a British colony. The British built railroads, factories, and hospitals. They also raised taxes and kept Indians from holding government offices. This angered the Indian people. By the early 1900s, Indians wanted independence. Mohandas Gandhi, who lead the independence movement, used peaceful

gatherings to protest British rule. India became independent in 1947. Indian Muslims were given land in northern India that became the country of Pakistan. The first prime minister of independent India was Jawaharlal Nehru. Nehru's daughter, Indira Gandhi, was another strong Indian leader. Today India is an industrial nation and a world power.

This book will show you how to draw some of India's sights and symbols. Directions are under each step. New steps are shown in red. Before you start to draw, you will need the following supplies:

- A sketch pad
- A number 2 pencil
- An eraser
- A pencil sharpener

These are some of the shapes and drawing terms you need to know to draw India's sights and symbols:

— Horizontal line

Oval

Rectangle

Shading

Squiggly line

Trapezoid

Triangle

| Vertical line

Wavy line

More About India

India is shaped somewhat like a baseball diamond. It is located in the southwestern part of the Asian continent. With an area of 1,269,438 square miles (3,288,000 sq km), India is the world's seventh-largest country. It is about one-third of the size of the United States. India's northwestern neighbor is Pakistan. To the northeast are Nepal, China, Bhutan, Bangladesh, and Myanmar. The Arabian Sea borders India to the southwest. The Bay of Bengal is to the southeast. The Indian Ocean separates southern India from Sri Lanka.

India has more than one billion people, making it the second-most-populated country in the world. About three-fourths of the population are descendants of India's early settlers, the Aryans. A small percentage of the population is made up of native peoples from more than 400 of the country's small tribes.

New Delhi is India's capital and its third-most-populated area, with 10 million citizens. It is located in the Northwest. Mumbai, once known as Bombay, is India's most-populated city, with 18 million people. It is

Jami Masjid in Delhi is India's largest mosque, which is a Muslim house of worship. It was built in 1656. The domes are made of marble, a type of hard, smooth stone.

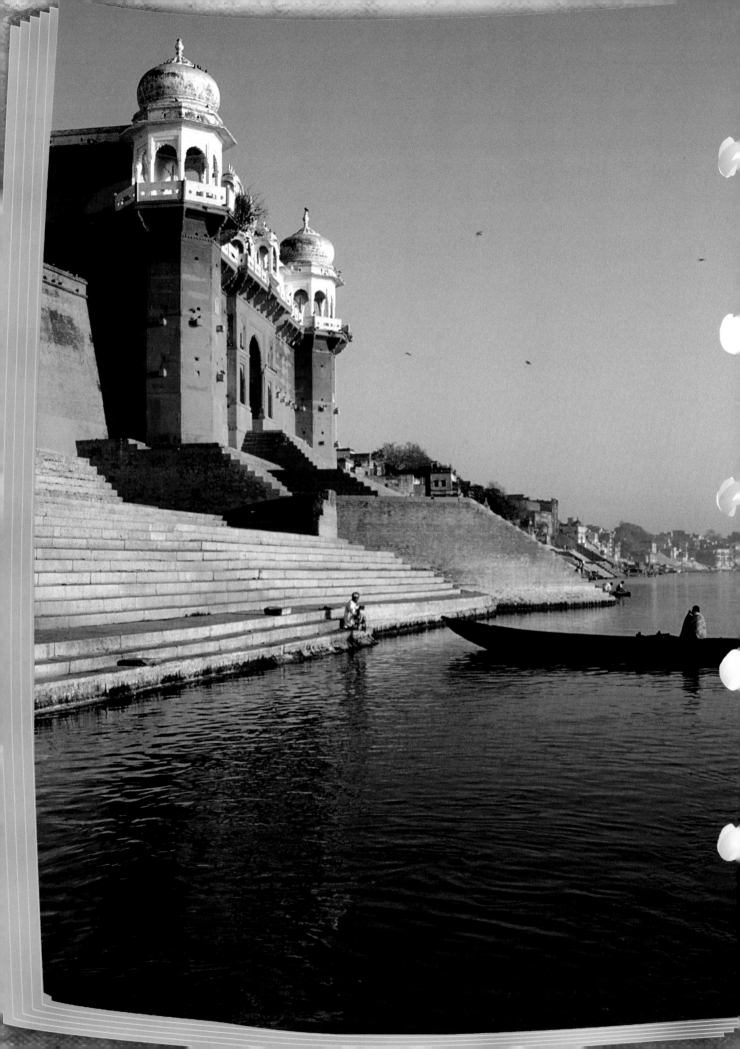

India's busiest port and the center of the nation's large film industry, known as Bollywood. India's most holy Hindu city is Varanasi, located in the northeast on the Ganges River. Hindus come to Varanasi to bathe in the Ganges. They believe that the river is holy and can wash away their sins.

India is the birthplace of the religions Hinduism, Buddhism, Jainism, and Sikhism. Most Indians are Hindus. Islam is the next-most-practiced religion.

The national languages of India are Hindi and English. Hindi grew from ancient Sanskrit. The government also recognizes 13 other languages that are spoken in different parts of India.

India's economy is based on agriculture and manufacturing. More than 60 percent of Indian people are farmers. Major crops include rice, wheat, cotton, tea, and coffee. India is a world leader in technology, including computer software and cellular phones. India's industries include chemicals, cloth, and steel. India is the world's largest producer of iron ore. Other natural resources include coal, diamonds, copper, and gold.

The Ganges River flows through Varanasi, a holy city to Hindus. The river is lined with about 90 ghats, which are sets of steps that lead into the Ganges. People walk down the ghats to bathe in the river and to wash away sins.

The Artist Sanjay Bhattacharyya

Sanjay Bhattacharyya is one of modern India's most gifted artists. He was born in Kolkata, once known as Calcutta, in 1958. Bhattacharyya was not a very good student during his early school years. When it was time to go to college, he applied to the Government Art College in Kolkata. He was

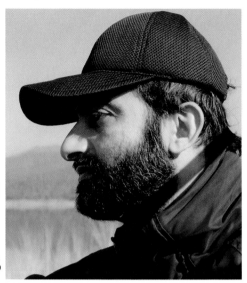

Sanjay Bhattacharyya

interested in this school because it did not have structured classes. This meant Bhattacharyya was free to travel around the Kolkata area to find subjects for his paintings. He especially liked to paint street scenes and old houses.

After Bhattacharyya graduated from Art College in 1982, he worked in advertising for several years. In 1987, Bhattacharyya started painting in watercolors. He sold many of his paintings, quit his work in advertising, and began to paint full time. He also began painting landscapes of the area around Kolkata and the Aravalli hills in western India.

Landscapes are pictures of natural scenery. Bhattacharyya paints landscapes in a realistic manner, which means he paints the scenery as he sees it. He is especially known for watercolor paintings in which he uses a special technique called a British wash. A wash is a thin layer of paint or water. By using this technique Bhattacharyya creates images with strong but soft colors. These soft colors help to convey the feeling of peace and harmony of the Indian countryside. Bhattacharyya lives in New Delhi now, but he still travels around the country to find images that inspire him.

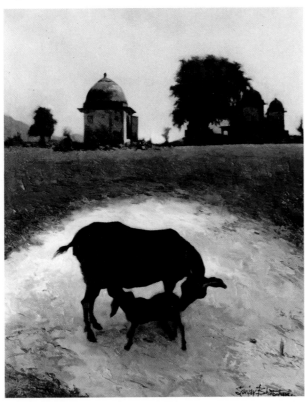

Bhattacharyya painted *Mother and Child*, which shows a female goat and her offspring, called a kid, in the Indian countryside. This oil-on-canvas painting measures 36" x 44" (92 cm x 113 cm).

Map of India

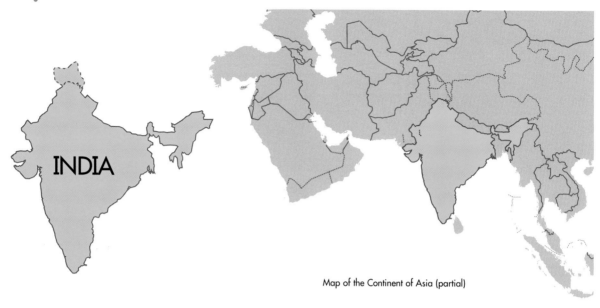

Map of the Continent of Asia (partial)

India's landscape includes snowcapped mountains, dusty flatlands, hills of sand, and jungles. The Himalayas, which are the highest mountains on Earth, separate northern India from the rest of Asia. *Himalaya* is a Sanskrit word that means "house of snow." India's highest mountain, Kanchenjunga, rises 28,208 feet (8,598 m) above the ground. That is more than 5 miles (8 km) high. India's major rivers, the Indus and the Ganges, begin in the Himalayas and flow into India's flat, central plain. This area is the best land in India for growing crops. The Vindhya Range runs across central India. The Deccan Plateau is in southern India. Much of northwestern India is covered by the Thar Desert. Eastern India is covered with forests. Southern India is rocky.

1

Start by drawing a large circle. Using a ruler, draw one vertical line and one horizontal line through the center of the circle.

2

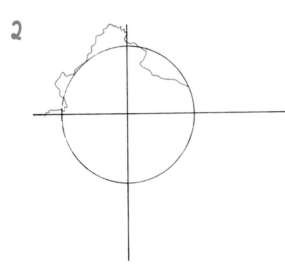

Use the circle and lines as a guide. Draw a long squiggly line to make India's northern border.

3

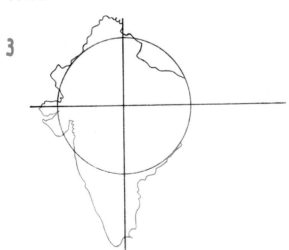

Draw another squiggly line for southwestern and southern India.

4

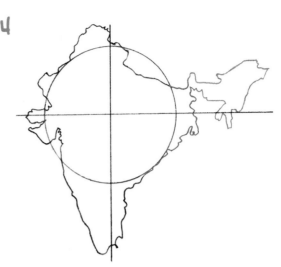

Draw more squiggly lines on the right side.

5

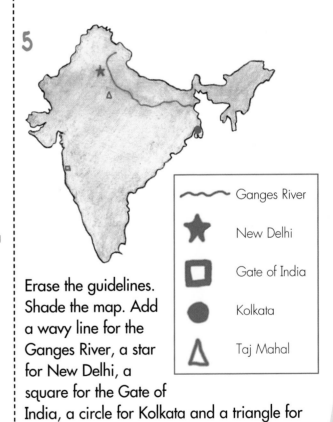

Erase the guidelines. Shade the map. Add a wavy line for the Ganges River, a star for New Delhi, a square for the Gate of India, a circle for Kolkata and a triangle for the Taj Mahal and you're done.

〰️	Ganges River
★	New Delhi
▢	Gate of India
●	Kolkata
△	Taj Mahal

Flag of India

India adopted its national flag in 1947. The top stripe of the flag is orange, which symbolizes the importance of work. Below the orange stripe is a white stripe, which represents light and the path to truth. The bottom stripe is green and stands for the earth. In the center of the white stripe is the blue Wheel of Law, which symbolizes progress.

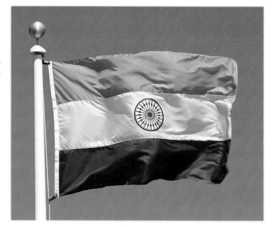

Currency of India

India's national currency is the rupee. One rupee equals 100 paisa. Coins come in amounts of 50 paisa and 1, 2, and 5 rupees. All coins show a value and the year they were made. They have the national emblem on one side. The 1-rupee coin shown here pictures corn, an important crop for India. The corn stands for progress and success. India's banknotes come in amounts of 5, 10, 20, 50, 100, 500, and 1,000 rupees.

Flag

1

Draw two rectangles. These are guides. Draw a circle, a line, and a triangle in the top of the tall, thin rectangle. This is the flagpole.

2

Draw the sides of the flagpole. Add wavy lines for the flag. Draw another line and two tiny rectangles at the left edge of the flag.

3

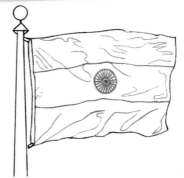

Erase the guidelines. Make two slightly wavy lines across the flag. Add two circles and a dot in the center. Make lines inside the big circle. Add lines to show folds.

4

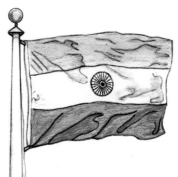

Draw a string between the tiny corner rectangles on the edge of the flag. Add shading. The bottom of the flag is darkest. The middle is lightest.

Currency

1

Draw a circle. Draw the number 1 as shown.

2

Write the word "RUPEE" and the number 2000 as shown. Draw two diagonal lines as shown. These are guidelines for the plants. Draw the writing at the top as shown.

3

Make the writing on the top darker and thicker. Begin to draw the corn as shown.

4

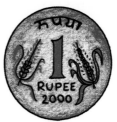

Finish drawing the corn. Finish the coin with detailed shading. The corn, numbers, and words are darkest.

India's National Emblem

India's national emblem was adopted in 1950. It is based on the *Lion of Sarnath*, a sculpture cut into the top of a famous pillar, or column, located in the region of Varanasi in Uttar Pradesh. Emperor Aśoka had the pillar made in the third century B.C., to commemorate 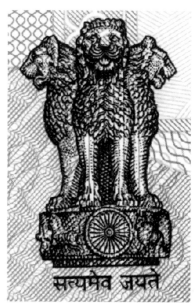 the place where Buddha gave his first lesson. The sculpture has four lions standing back to back on top of an abacus, or top part of a column. In the national symbol, only three of these lions can be seen. They symbolize courage, power, and confidence. On the abacus on the sculpture are four smaller animals that represent the four directions. A lion stands for north, a horse for south, an elephant for east, and a bull for west. Only the bull and the horse appear on the emblem. The Wheel of Law, which stands for progress, appears between the animals. Beneath the abacus is the motto *Satyameva Jayate*, which means "Truth alone triumphs."

1
Draw a rectangle as shown. This will become the abacus. Draw a long vertical line in the middle. This is a guideline.

2
Draw three circles in the middle of the rectangle. Add a curved line on top of the rectangle. Draw two small ovals on top. These will become the feet of the middle lion.

3
Draw three circles as shown. Draw wavy lines on the sides of the rectangle.

4
Draw the first lion. He has a face with eyes, a nose, and a mouth. His mane is wavy. Make his body and legs with slightly curved lines. Erase the sides of the rectangle.

5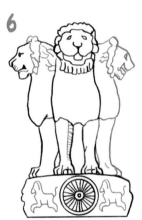
Erase the guideline and guide circles. Use lines to draw the lion's paws. Use curved lines to draw the lion on the left side. Draw straight lines inside the abacus' circle. Make a small circle in the circle's center.

6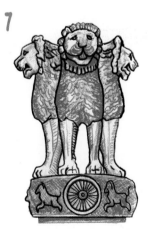
Erase the guide ovals from the middle lion's paws. Use squiggly lines to add the mane on the lion on the left. Add lines to the snout and leg. Draw the lion on the right. His mouth is open. Draw an animal shape on either side of the abacus' circle.

7
Draw a small rectangle underneath the abacus. Finish the emblem with shading. The edges of the lions' chests are dark. Scribble dark and light squiggly lines to make the fur. Shade the abacus.

The Lotus

The lotus, *Nelumbo nucifera*, is India's national flower. The lotus grows to be from 1 to 8 feet (.3–2.4 m) tall in shallow waters throughout India. Flowers of the lotus range from 4 to 10 inches (10–25 cm) across and are usually pink or white in color. The lotus can be eaten, and it is sometimes grown for food. The lotus is sacred to both Buddhists and Hindus. For Buddhists the lotus represents purity. For Hindus the lotus symbolizes the center of the universe. It stands for purity, beauty, and goodness. The Hindu goddess of good fortune, Lakshmi, is often shown sitting on a lotus and holding one in her hand.

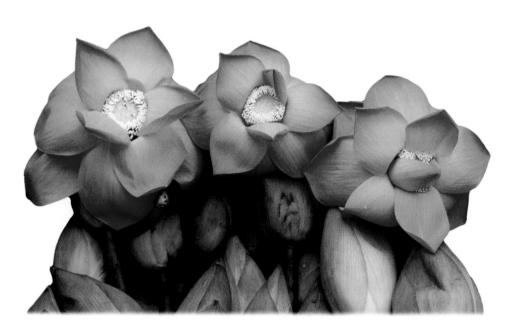

1

Begin by drawing a small circle. Draw a wavy, round shape in the middle. It should not be perfectly round. This is the center of the first flower.

2

Add the three petal shapes using curved lines. Draw another circle and center.

3

Draw more petals on the first flower. Erase any part of the circle that runs through a petal. Add petals to the second flower. Make the flower's center wider at the bottom.

4

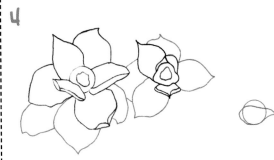

Erase the sides of the second flower's center circle so that it looks like the center shown. Add more petals to the first and second flowers. Draw a third center with a petal overlapping it.

5

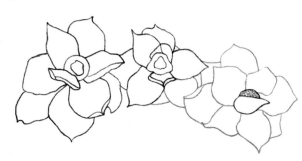

Add petals to the second flower. Erase part of the center circle of the third flower. Draw petals for the third flower. Make tiny circles in the center of the third flower.

6

Make tiny circles in the centers of the first two flowers. Shade the flowers, making the outside of the petals the darkest parts.

The Royal Bengal Tiger

The Royal Bengal tiger, *Panthera tigris tigris*, is the national animal of India. This large cat is about 9 feet (3 m) long and can weigh as much as 480 pounds (218 kg). The Royal Bengal tiger is yellow-orange with black stripes. The stripes help the tiger to hide among trees and plants while it searches for wild deer and cattle to eat. The tiger is very strong and fast. It has excellent hearing and vision, and can see five times better at night than humans can. The Bengal tiger is found everywhere in India except the northwest region. It is an endangered species. An endangered species is a plant or an animal that is in danger of dying out forever. In 1973, the Indian government started Project Tiger to protect these beautiful animals.

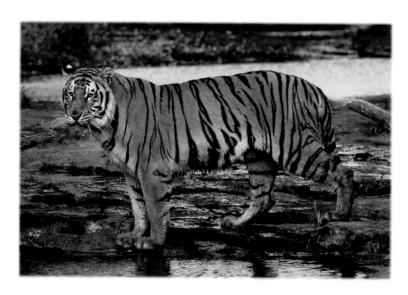

1

Start by drawing a circle for the head. Draw straight lines to make guides for the body and legs.

2

Add circles for the body. The front of the body has the largest circle. The end of the body has the smallest circle.

3

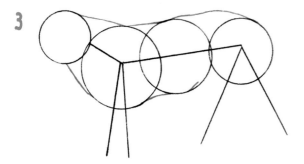

Connect the circles with slightly curved lines.

4

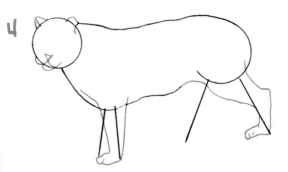

Erase most of the body circles. Begin drawing the outlines for the legs. Draw the ears, mouth, and nose. The nose is a triangle.

5

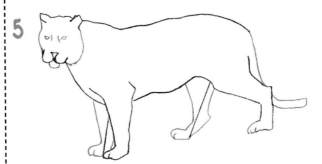

Complete the tiger's legs. Complete the tiger's head and erase the head circle. Draw the eyes. Draw the tail and erase the back circle.

6

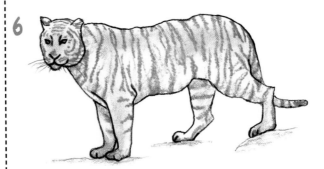

Erase the remaining guidelines. Add the stripes. Shade your tiger. You can rub the picture gently with your finger to blend the shading. Use an eraser to bring out white highlights under the belly and on the legs. Draw whiskers.

Hinduism

Hinduism began in India more than 3,000 years ago. *Hindu* comes from a Sanskrit term that means "people who live by the Indus River." Hinduism is based on the caste system, reincarnation, and karma. Reincarnation means that when a person dies, he or she is reborn

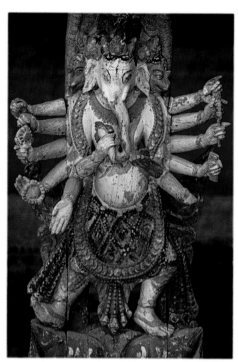

as another person or an animal. Karma is an idea that explains how the good and bad deeds a person does in one life affect the person's next life. Hindus worship many gods, all of whom are thought to be different forms of Brahma, creator of the universe. Two important gods are Vishnu, who preserves the universe, and Shiva, who can destroy the universe. Hindus worship many other gods who they believe will help them to deal with daily life. Ganesha, the Lord of New Beginnings, is a popular god. Hindus pray to him when they begin new tasks. He has the head of an elephant, many arms, and a round belly.

1

Draw a large rectangle. Make a vertical line down the middle. Draw two ovals at the bottom.

5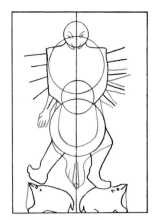

Draw eyebrows, eyes, and tusks. Use *V*'s and curved lines to start the arms. Add a *U* in the bottom circle and draw the skirt. Erase the leg and oval guidelines. Add lines by the rats.

2

Draw a small circle slightly higher than the middle of the box. Draw two large circles that cross into the top and bottom of the first circle.

6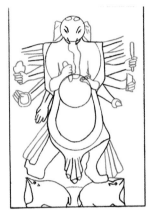

Erase extra lines. Add lines to the skirt. Draw a trunk, ears, and two ovals. Connect the rats with a line. Draw more arms and hands. Some hands hold objects.

3

Add a small circle for the head. Draw four guidelines for the legs. Ganesha will be standing on the two ovals, which will become ratlike animals.

7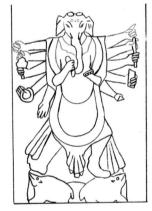

Finish the arms and hands. Erase the arm guidelines and the top part of the center circle. Add a necklace and lines in the forehead. Add curved lines near the necklace.

4

Draw a shield shape for the upper body. Make short guidelines where the arms will be. There should be five lines on each side. Draw the outline of the legs. Add heads, feet, and tails to the ovals.

8

Use shading to make decorations. Try using the side of your pencil lead rather than the point for the shading. Finish Ganesha with more shading.

Siddhārtha Gautama

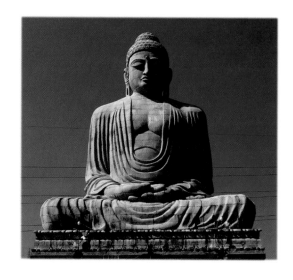

About 2,500 years ago, the Indian prince Siddhārtha Gautama left his palace and all of his riches behind to search for the cause of human suffering. In the village of Bodh Gayā, he rested under a Bodhi tree to meditate and to pray. It is said that under this tree he reached enlightenment and became the Buddha, or the Enlightened One. He realized that wanting things, such as wealth or success, causes a person to suffer because one cannot always get or keep these things. Buddha's enlightenment became the basis of a new religion called Buddhism. Buddhism teaches people to free themselves from wanting things by giving up all material goods. After Buddha died in 486 B.C., his followers built temples to honor him. The Mahabodhi Temple in Bodh Gayā is the holiest Buddhist place in India, because it is located at the place where Buddha became enlightened. The temple is decorated with fancy carvings and statues of the Buddha.

1

Draw two rectangles. Make the top rectangle shorter and wider. Add lines at the sides of the bottom rectangle.

2

Erase the sides of the bottom rectangle and add a horizontal line. Draw lines around the top rectangle as guides for the knees. Draw two circles.

3

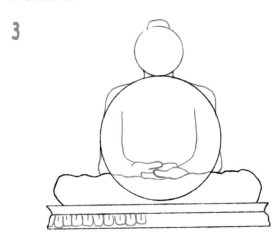

Erase extra lines. Draw the lines for the arms and hands, showing the thumbs and pointing finger of each hand. Make a curved line for the hair bun shape. Add two short lines for the neck. Use curved lines and short, straight lines to start the decorations at the bottom.

4

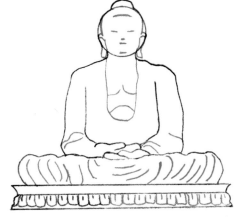

Finish the bottom decorations. Erase the big circle. Begin the face. Add long ears. Draw the chest. Draw lines to show folds in the robe.

5

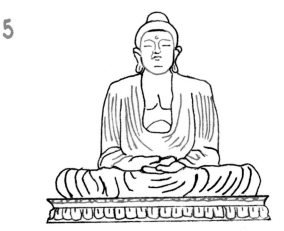

Finish the face. Erase the top circle. Make fabric lines in the arms. Make tiny circles and ovals in the top part of the bottom rectangle.

6

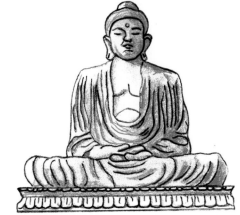

Finish Buddha with shading. The right side of the statue is darker than the left. Try using the side of the pencil lead instead of the point for some shading.

27

Ellora Caves

Located in western India, the Ellora Caves are a series of temples carved into the walls of a rock cliff. There are 34 temples that stretch for 1.2 miles (2 km). They were carved between A.D. 600 and A.D. 1000 by

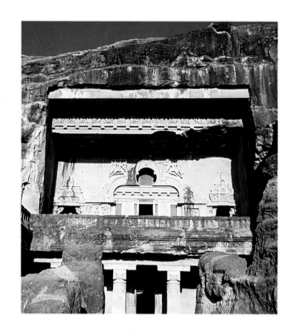

followers of Hinduism, Buddhism, and Jainism. The first 12 caves are Buddhist temples. They are the oldest temples. The next 17 caves are Hindu temples, and the last 5 caves are Jain temples. A few of the temples are two or three stories high. Many have courtyards, statues of gods and goddesses, and ornate carvings in the walls. The most remarkable temple is called the Kailasha Temple. It represents Mount Kailasha, the home of the Hindu god Shiva. Kailasha Temple is 266 feet (81 m) tall and 154 feet (47 m) wide. Carvings of scenes from Hindu stories, life-size statues of elephants, and tall columns with lotus carvings on them decorate the temple.

1 Draw a large rectangle. Inside, add three horizontal lines.

2 Draw two more horizontal lines near the bottom. Add another horizontal line and two sloping lines to the lines you drew above. This makes a trapezoid.

3 Add two more lines inside the trapezoid. Add a doorway at the bottom of the rectangle.

4 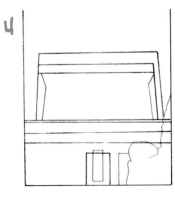 Erase part of the horizontal line that cuts through the trapezoid. Draw lines inside as shown. Draw a small rectangle in the doorway. Add two more straight lines and begin drawing rocks.

5 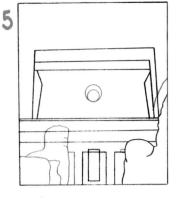 Erase the lines that run through the rock. Add more rocks on either side. Add more straight lines. Draw two circles in the center of the rectangle. Make them touch.

6 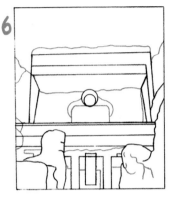 Use wavy lines to make more rocky walls and ceilings. Add an opening under the circles. Add details to the temple. Erase lines that run through the rocks.

7 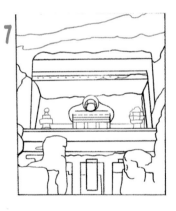 Add small doors under the circles. Decorate this doorway and add fancy posts on either side of it. Add more wavy lines at the top and bottom.

8 Add more fancy decorations. Finish by shading your picture. The doorways and ceilings are very dark.

29

The Qutb Minar

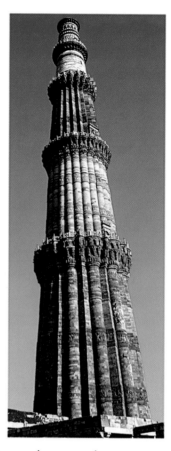

During the thirteenth century, Muslims from the countries of Turkey and Iran invaded northern India. Muslim culture and Islamic religion flourished in northern India for the next 600 years. Islam is based on the teachings of Muhammad, the prophet of the Muslim God, Allah. In 1193, Qutb-ud-Dīn Aybak, a Muslim leader, conquered northern India and made Delhi the capital of India's Muslim kingdom. In honor of the victory, Qutb-ud-Dīn Aybak built the Qutb Minar. It is the tallest stone tower in India. Made of red sandstone, the Qutb Minar is 238 feet (72.5 m) tall, 47 feet (14.3 m) wide at the base, and 9 feet (2.7 m) wide at the top. The sides of the tower are fluted, which means that they have long, narrow cuts in them. The history of the Qutb Minar is written on the tower walls. Verses from Islam's holy book, the Koran, are carved into the tower's gate. The Qutb Minar is one of the finest examples of early Islamic architecture in India.

1

At the bottom of your page, draw a horizontal line. Add two long, straight lines that end with a curved line at the top. The lines should get closer together toward the top.

2

Draw curved lines to make ring shapes on the tower. There are four rings. The bottom ring is the biggest.

3

Begin drawing straight lines on the tower. Begin making squiggly lines on the edges of the three bottom rings. Make a curved shape inside the top ring. Add a tiny curved line and two straight lines at the top of the tower.

4

Finish the straight lines and the edges of the rings. Make lines and U shapes in the bottom rings. Draw small rectangular shapes on the right side, just above the bottom two rings. Add decoration to the top of the tower Erase the ring guidelines and any extra lines.

5

Shade your tower. The left side is darker than the right side. Use the side of the pencil point to make dark sideways stripes across the tower.

The Taj Mahal

The Taj Mahal is said to be one of the most beautiful buildings in the world. It is located in Agra, just southeast of New Delhi. The Taj Mahal was built by the fifth emperor of the Mughal Empire, Shāh Jahān, as a memorial to his wife, Mumtāz Mahal, who died in 1631. The memorial was built to look like a heavenly place described in the Koran. It took 22 years and 20,000 workers to build the Taj Mahal. Surrounded by gardens and pools, the Taj Mahal is 186 feet (57 m) wide on each side and is made of white marble. Artists carved decorations in the walls. They added precious stones to form colorful pictures of flowers and plants. To complete the perfect look of balance of the Taj Mahal, the builders added four tall, skinny towers, called minarets, around the building.

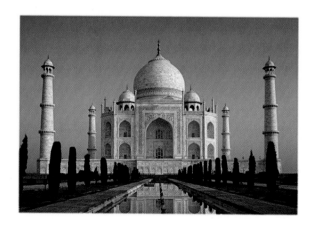

1

Draw a large rectangle. Make a vertical line down the center. Draw a horizontal line near the bottom.

2

Add three lines atop the horizontal line to make a long, thin rectangle. At the bottom, make two sloping lines and connect them with a short line.

3

Add lines to make a shorter rectangle on top of the long, thin rectangle. Make a vertical line on each side of it. These are the guidelines for minarets. Draw two more slanting lines at the bottom.

4

Start at the bottom of the long, thin rectangle, which will be the base, and draw three lines that make another rectangle. Add a circle on top of it. Draw two more minaret guidelines.

5

Use lines to connect the circle and rectangle. Draw a point on the top of circle. Draw two slightly rounded shapes next to the top of the vertical rectangle. Make a doorway with a pointy top and vertical lines in the wide rectangle. Outline the minarets. Add one more line at the bottom. Erase extra lines.

6

Erase the guidelines. Add horizontal lines on the front two minarets. Draw two smaller circles on the rounded shapes. Add windows with pointy tops. Make lines around and in the main doorway. Add tree shapes. Add details to the dome, the back two minarets, and the main building of the Taj Mahal. Make one last sloping line at the bottom.

7

Erase extra guidelines. Finish with shading. The left sides of the building and towers are darker than the right sides. The windows and trees are dark. Use squiggly lines to shade the water.

33

Maharaja Ranjit Singh and the Golden Temple

In the late 1700s, Maharaja Ranjit Singh joined together the Sikh communities in the state of Punjab and formed India's first Sikh kingdom. The Sikh religion is a combination of Hinduism and Islam. The Sikhs' holiest place is the Golden Temple in

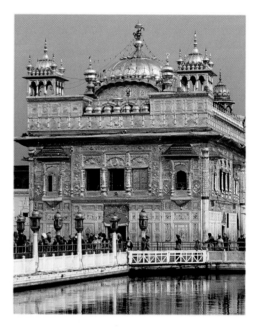

Amritsar, located on Punjab's western border. The dome is covered with sheets of gold that were donated by Maharaja Singh. The temple is three stories high. Each side is 40.5 feet (12.3 m) long. The doorways on each side symbolize the openness of the temple to all four castes of India. The temple stands on an island in the middle of a lake. It is connected to the Sikhs' government building by a marble bridge. Decorations inside the temple include sculptures, gold trim, and precious stones. The Adi Grantha, the Sikhs' holy book, is kept on the second floor. Songs from the book are sung from morning until night.

1

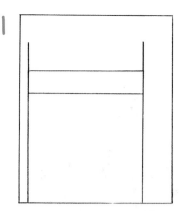

Begin by drawing a large rectangle. Add two vertical lines and two horizontal lines inside. This will be the front of the temple.

2

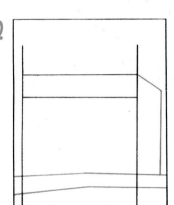

Draw two crooked lines near the bottom of the temple. They will be the fence. Add the side of the temple on the right. These lines form a trapezoid.

3

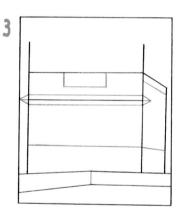

Add three straight lines to make a small rectangle. Add more straight lines as shown.

4

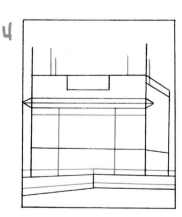

Draw short vertical lines on the top. Add crossing vertical and horizontal lines in the middle. Add more slightly sloping lines at the bottom.

5

Add vertical lines across the top of the front. Add horizontal lines on the top right and left side. Add more straight lines in the middle. Draw a rectangle, too.

6

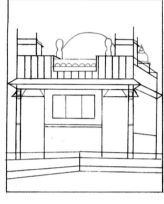

Draw a curved line to make a dome on top. Draw two shapes next to the dome. Draw a smaller dome on the right side. Add details to your drawing as shown. Erase extra lines.

7

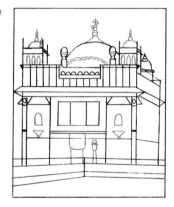

Add more domes. Keep adding decorations to the temple. There are arched windows, triangles, squiggly lines, and more.

8

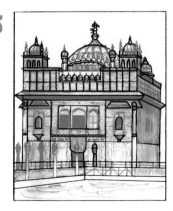

Look at the photo on page 34 to keep adding to the temple's decorations. Make lampposts, too. Finish with shading. Erase extra lines.

Gandhi

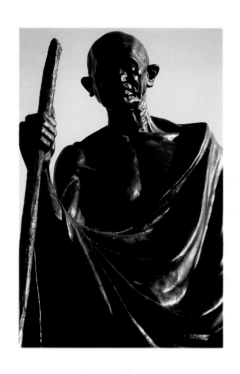

Mohandas Gandhi is called the Father of the Nation because he led India to independence from England. Gandhi was born in 1869 in Porbandar, a town by the Arabian Sea. After studying law in England, Gandhi moved to South Africa, which was then under British rule. He saw how the British did not give civil rights to Indians living there. Gandhi decided to promise his life to India's fight for independence. He was jailed several times during his life for protesting anti-Indian laws. He returned to India in 1915 and protested British rule by organizing peaceful protests and hunger strikes. In 1930, to protest the British tax on salt, Gandhi organized the Salt March. The protesters marched to the coastal town of Dandi and made their own salt by boiling a lump of mud and a pinch of salt from the shore in seawater. In 1947, India became independent. Gandhi was killed in 1948. The Indian people built many statues to honor him.

1 Draw a large rectangle. Draw a circle at the top for the head. Make straight lines where the shoulders, body, and arm will be. Draw an oval for the hand.

4 Erase extra lines around the head. Add long curved lines for the robe. Add arm lines. Add lines on the fingers. Draw two short lines at the top of the staff.

2 Add a long, straight line for the staff. Draw lines for the sides of the head, neck, and shoulders.

5 Erase the rest of the guidelines. Draw the eyes, nose, chin, and mouth. Add more curved lines for the fabric of Gandhi's robe.

3 Make the staff wider by drawing outside lines. Begin drawing the finger shapes. They are flat ovals. Add ears and lines for the face. Add lines for the chest.

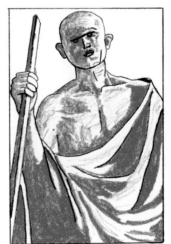

6 Finish with shading. There is a lot of dark shading on the statue. The left side of the face is very dark. So are the folds of the fabric.

37

The Victoria Memorial

Calcutta was the capital of the British Empire in India during the eighteenth and nineteenth centuries. Today it is called Kolkata. The city is located in eastern India, near the country of Bangladesh.

When Victoria, queen of England and empress of India, died in 1901, British residents in Kolkata built the Victoria Memorial in memory of her. The marble building is 338 feet (103 m) long, 228 feet (69 m) wide, and 184 feet (56 m) high. It is decorated with statues and paintings that show scenes from Queen Victoria's life. On top of the memorial is a statue called the Angel of Victory. The building is also a museum that houses pictures and statues of people who were important to the history of India.

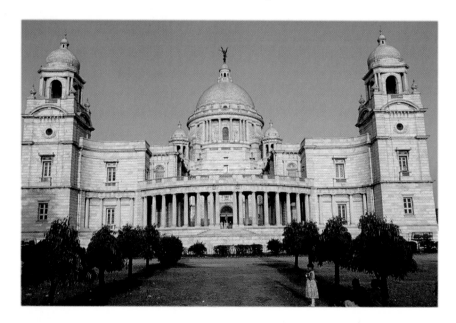

1

Start by drawing a horizontal line. Draw a vertical line from the center.

2

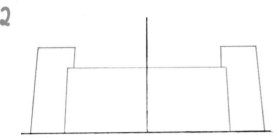

Add lines to make the three shapes shown. They all slope a little inward.

3

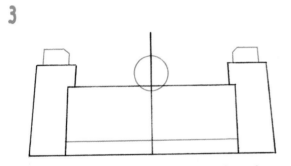

Add two shapes on top of the side columns. Add a circle in the center. Draw a horizontal line across the center trapezoid.

4

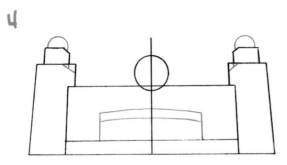

Add round shapes on top of the side columns. Make slanted lines across the inside corners. Draw two vertical lines connected by two curved lines in the center.

5

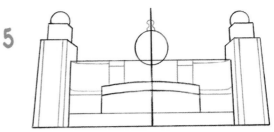

Add vertical lines on the side columns. Add the lines within the center trapezoid. Some are straight and some curve slightly. Add the round shapes on top of the circle.

6

Erase part of the horizontal line and the bottom of the circle. Draw the center building and more lines to each side. Add dome tops.

7

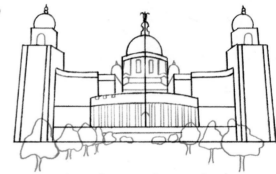

Add arched windows and vertical columns. Make a small doorway. Add two small domes behind the center dome. Add lines to the center building. Draw tree shapes with wavy lines.

8

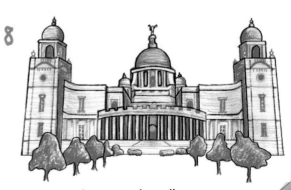

Erase extra lines. Make tall windows and more columns. Add decorations. Finish with shading.

39

Saris

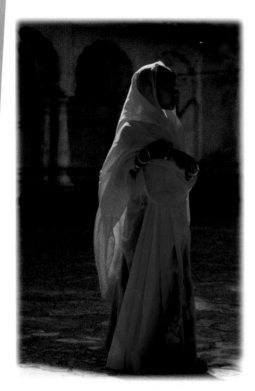

One traditional Indian costume is called a sari. It is a single piece of cloth measuring between 6 and 9 yards (5.5–8 m) long and 6.5 feet (2 m) wide. The sari can be wrapped around the body in many different ways. Its color, fabric, and style of draping have to do with the age, job, or caste of the person wearing it. The region in which the person lives can also affect the look of the sari. Men may drape a sari around their shoulders or wrap it into a turban around their heads. A turban is a headdress made from a long cloth. Some women drape it around their waists, then throw the length of the leftover cloth over one shoulder. Other people wrap the middle section of the sari around their waists, then wrap the portion leftover from each side of the sari around each leg. For special events, such as weddings, women wear saris that are made of silk with beautiful decorations that are sewn with gold thread.

1

Draw a vertical line as shown. Draw a circle. This will be a guide for the head. Draw a large oval shape as shown.

2

Draw the face and head as shown. Begin drawing the fabric.

3

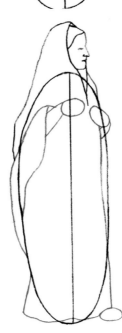

Erase the circle. Draw the arms and hands as shown. Add an eye. Draw more of the fabric shape and foot as shown.

4

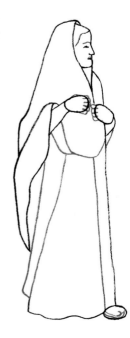

Erase the vertical line and oval. Draw the hands. Draw the fabric folds as shown. Draw the foot. Add an eyebrow and the top lip.

5

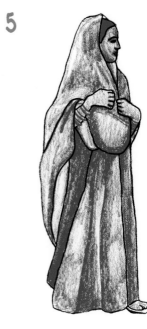

Erase the circles for the hands and feet. Draw the bracelets. Finish with detailed shading. The hair and eyes are very dark.

Gateway of India

The Gateway of India is the city of Mumbai's most famous sight. Mumbai, formerly called Bombay, is located on India's west coast. The Gateway of India marks the entrance to Mumbai. It is the first thing people see when they arrive by ship. The gateway was the last thing that British soldiers saw when they left India after the country was granted its independence in 1947. The arch was built to honor the visit of King George V and Queen Mary of England in 1911. Unfortunately, the British king and queen saw only a cardboard model of the monument, because the construction of the gateway did not begin until 1915. The 83-foot-high (25-m-high) gateway was constructed on the shores of the Arabian Sea, from concrete and yellow basalt, a type of rock. On each side of the arch are large halls that can hold as many as 600 people.

1

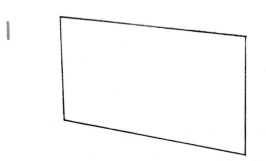

Start by drawing a rectangle. The left side is shorter than the right side.

2

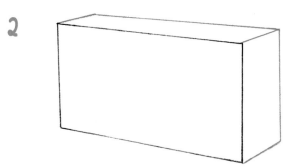

Add a top and a side to the rectangle. The lines are all straight.

3

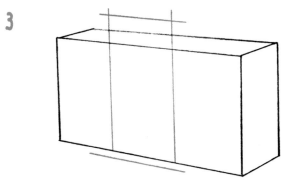

Draw two vertical lines as shown. Add a straight line that crosses their tops. Draw another line below the main rectangle.

4

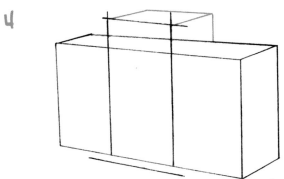

Add more straight lines at the top of the lines you just drew.

5

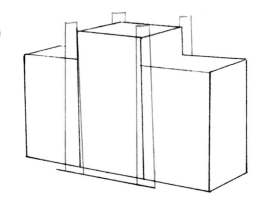

Erase extra lines. Draw thin shapes.

6

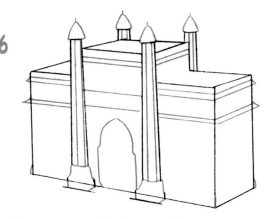

Add more straight lines to the gateway. Draw pointy tops on the columns. Use curved lines to make the gate's opening.

7

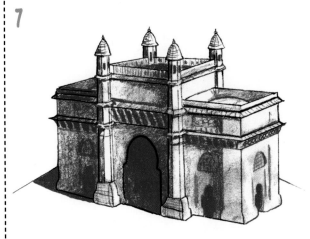

Erase extra lines. Add some short, straight lines. Shade in more doorways, windows, and decorations. Parts of the gateway are very dark. You can use the side of the pencil lead to make smooth shadows. Use your finger to smudge the shading and soften the edges.

Timeline

2500–1800 B.C.	Indus Valley civilization develops in northern India.
1500 B.C.	Aryans migrate to northern India and found the Hindu religion.
566 B.C.	Siddhārtha Gautama, the Buddha, is born.
500s B.C.	Buddhism founded by the Buddha.
321–104 B.C.	Age of the Maurya dynasty.
269–232 B.C.	Maurya king Aśoka reigns.
A.D. 319	The Gupta Empire in northern India begins.
985	The Chola dynasty rises to power in southern India.
1193	Qutb-ud-Dīn Aybak conquers northern India.
1206	Qutb-ud-Dīn Aybak forms the first Muslim dynasty in India.
1526	Mughal prince Babur from Asia establishes the beginning of the Mughal Empire.
1526–1857	Indian soldiers rebel against British East India Company.
1790–1839	Maharaja Ranjit Singh establishes the first Sikh kingdom.
1600s–1800s	The East India Company establishes trading posts in India.
1857	Indian soldiers rebel against the East India Company.
1858	The East India Company's rule ends and India becomes part of the British Empire.
1869	Mohandas Gandhi is born.
1920	Gandhi takes over India's movement for independence.
1930	Gandhi leads the Salt March in protest over the British tax on salt.
1947	India is granted independence from England.
1947	Jawaharlal Nehru is chosen to lead India's new government.
1948	Gandhi is killed by Nathuram Godse.
1966	Indira Gandhi becomes prime minister of India.
1990s	Cities begin to be renamed to reflect regional languages. Bombay becomes Mumbai and Calcutta becomes Kolkata.

India Fact List

Official Name	Republic of India
Area	1,269,438 square miles (3,288,000 sq km)
Population	1,027,015,247
Capital	New Delhi, population, 10,000,000
Most-Populated City	Mumbai, population, 18,000,000
Industries	Information technology, chemicals, cloth, steel
Agriculture	Rice, wheat, sugarcane, tea, coffee, cotton
Natural Resources	Coal, iron ore, diamonds, copper, gold
National Flower	Lotus
National Tree	Banyan
National Bird	Peacock
National Animal	Royal Bengal Tiger
National Fruit	Mango
Anthem	"Jana Gana Mana" ("Thou Art the Ruler of the Minds of All People")
National Languages	Hindi and English
National Currency	Rupee
Highest Mountain Peak	Kanchenjunga, 28,208 feet (8,598 m)

Glossary

abacus (A-ba-kus) The top of a tall post that bears the weight of a building.

agriculture (A-grih-kul-chur) The science of growing crops and raising animals.

architecture (AR-kih-tek-cher) The art of creating and making buildings.

Buddhism (BOO-dih-zum) A faith based on the teachings of Buddha, started in India.

carvings (KARV-ingz) Shapes that are cut from stone, wood, or clay.

caste system (KAST SIS-tum) A system that put people into different levels of society. People in higher castes have more rights than people in lower castes.

chemicals (KEH-mih-kulz) Matter that can be mixed together to cause changes.

civil rights (SIH-vul RYTS) The rights that citizens have.

commemorate (kuh-MEH-muh-rayt) To remember officially.

confidence (KON-fih-dents) A firm belief in oneself and one's abilities.

culture (KUL-chur) The beliefs, practices, and arts of a group of people.

descendants (dih-SEN-dents) People born of a certain family or group.

developed (dih-VEH-lupt) Worked out.

donated (DOH-nayt-ed) Gave money or help.

dynasty (DY-nas-tee) A line of rulers who belong to the same family.

emblem (EM-blum) A picture with a saying on it.

endangered species (en-DAYN-jerd SPEE-sheez) Species, or kinds of animals, that will die out if people do not protect them.

enlightenment (en-LY-ten-ment) A state of having great knowledge or wisdom.

eventually (ih-VEN-chuh-wel-ee) At some point.

founded (FOWN-did) Started.

Hindu (HIN-doo) Having to do with someone who believes in Hinduism, a faith that was started in India.

holy (HOH-lee) Blessed; important for reasons of faith.

industries (IN-dus-treez) Businesses in which people make money creating products.

invaded (in-VAYD-ed) Entered a place in order to attack and take over.

Islamic (IS-lom-ik) Having to do with Islam, a faith based on the teachings of Muhammad and the Koran.

Jainism (JY-nih-zem) A faith in which people believe that freedom is reached by knowing what is right and behaving well.

karma (KAR-muh) The force of a person's actions, which shows that every action has an effect.

maharaja (mah-uh-RAH-jah) An Indian prince.

material (muh-TEER-ee-ul) Fabric or cloth.

meditate (MEH-dih-tayt) To think very hard about something.

memorial (meh-MOR-ee-al) Something built to remember a person.

minarets (mih-neh-RETS) The slender towers of a mosque.

motto (MAH-toh) A phrase that stands for something or that states what someone believes.

Mughal (MUH-gul) Muslim people who ruled India from 1526 to 1857.

Muslim (MUZ-lum) Having to do with people who practice the faith of Islam.

natural resources (NA-chuh-rul REE-sors-ez) Things in nature that can be used by people.

nonviolence (non-VY-lens) The state of being peaceful or not fighting back.

pillar (PIH-lur) A strong, tall post that helps to hold up a building.

preserves (prih-ZURVZ) Keeps something from being lost or destroyed.

prime minister (PRYM MIH-nih-ster) A leader of a government.

promoted (pruh-MOHT-ed) To be raised in rank or importance.

prophet (PRAH-fit) Someone who says he or she brings messages from God.

purity (PYUR-ih-tee) Perfection; cleanliness.

rebelled (ruh-BELD) Disobeyed the people or country in charge.

reincarnation (ree-in-kar-NAY-shen) Rebirth into new forms of life.

residents (REH-zih-dents) People who live in a certain town or city.

Sikhism (SEEK-ih-zem) A religion founded in northern India that combines elements of Hinduism and Islam.

symbolizes (SIM-buh-lyz-ez) Stands for something else.

traditional (truh-DIH-shuh-nul) Having to do with a way of doing something that is passed down through the years.

triumphs (TRY-umfs) Wins, or is successful.

Index

Web Sites

Due to the changing nature of Internet links, PowerKids Press has developed an online list of Web sites related to the subject of this book. This site is updated regularly. Please use this link to access the list:

www.powerkidslinks.com/kgdc/india/